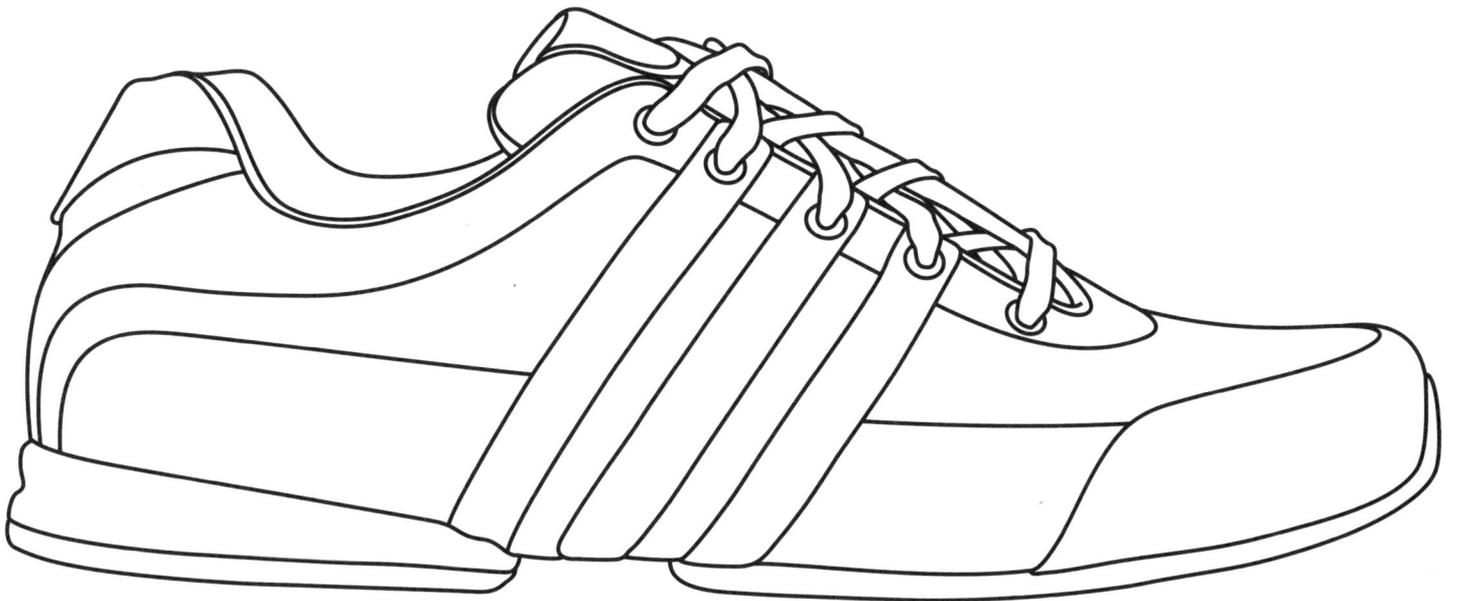

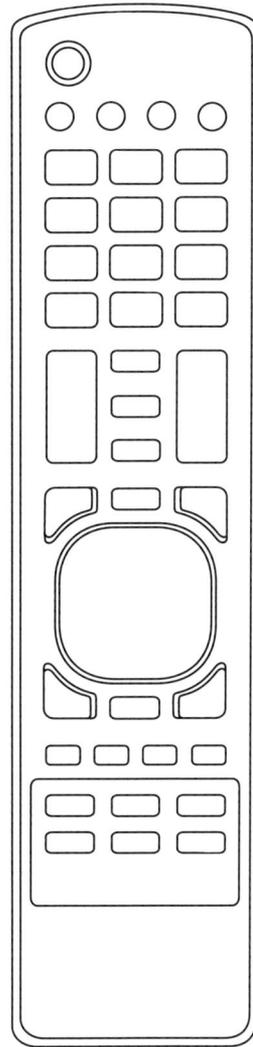

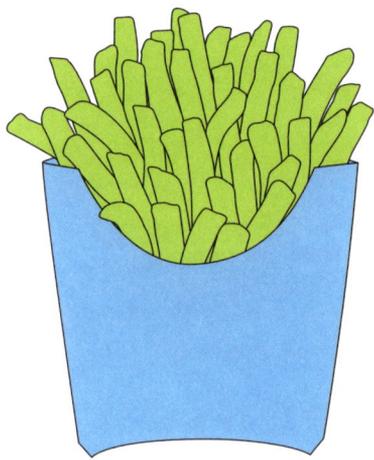

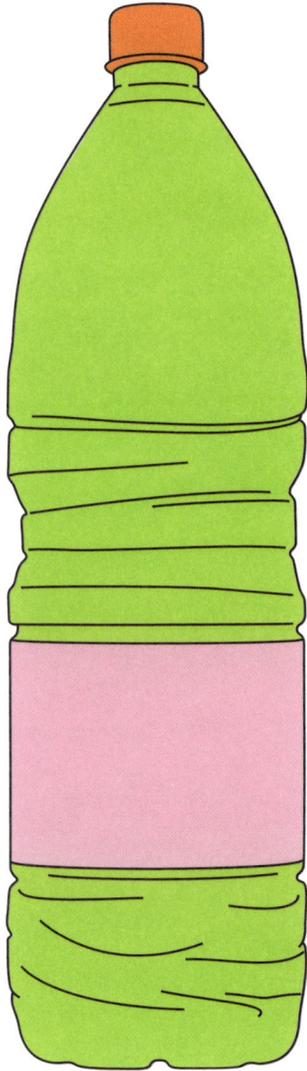

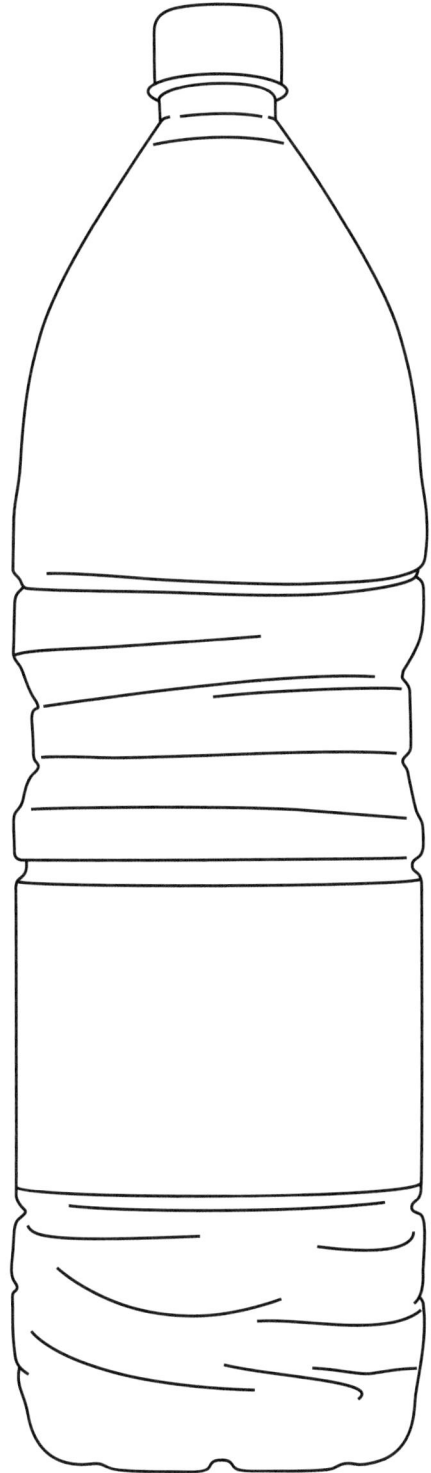

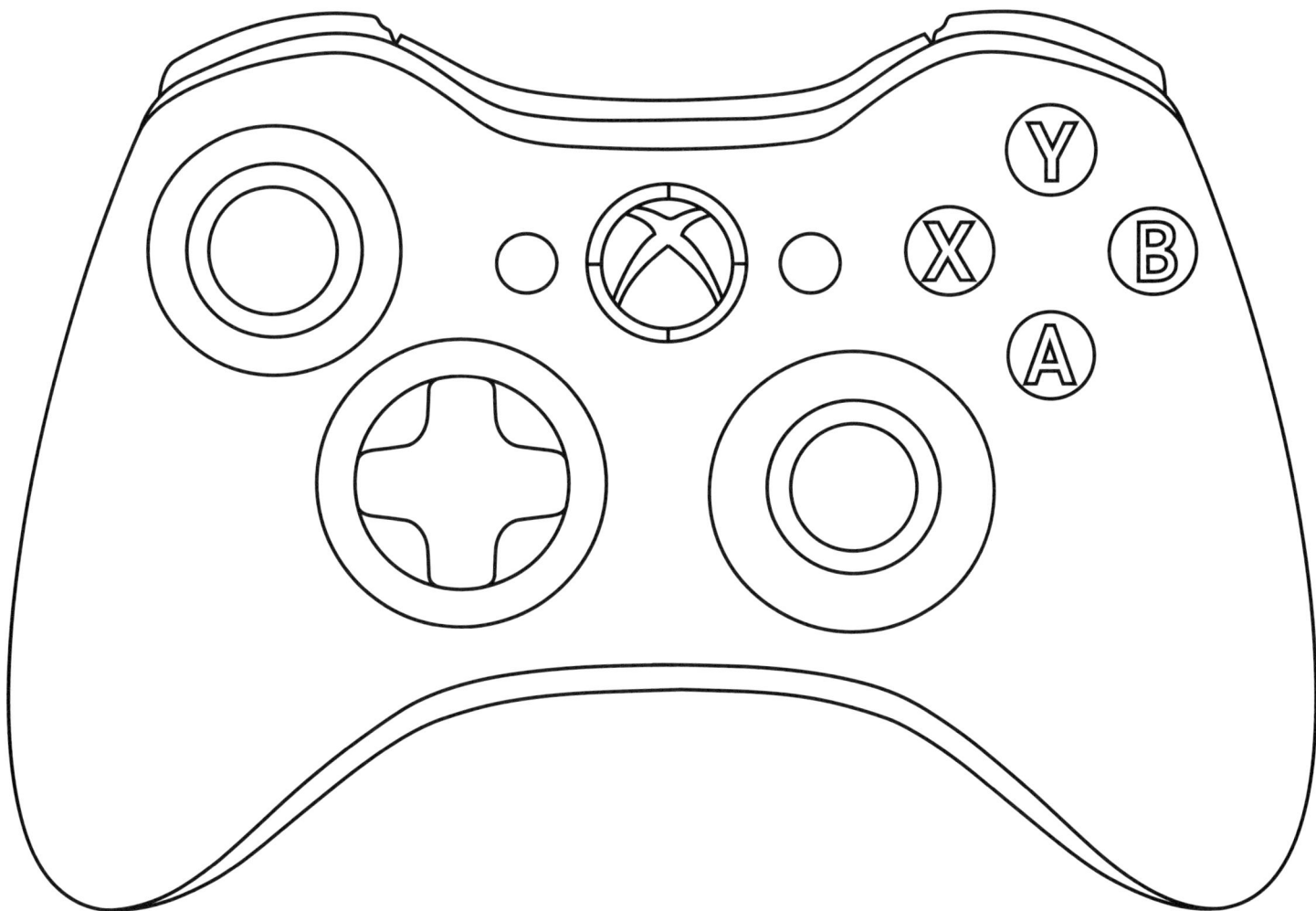

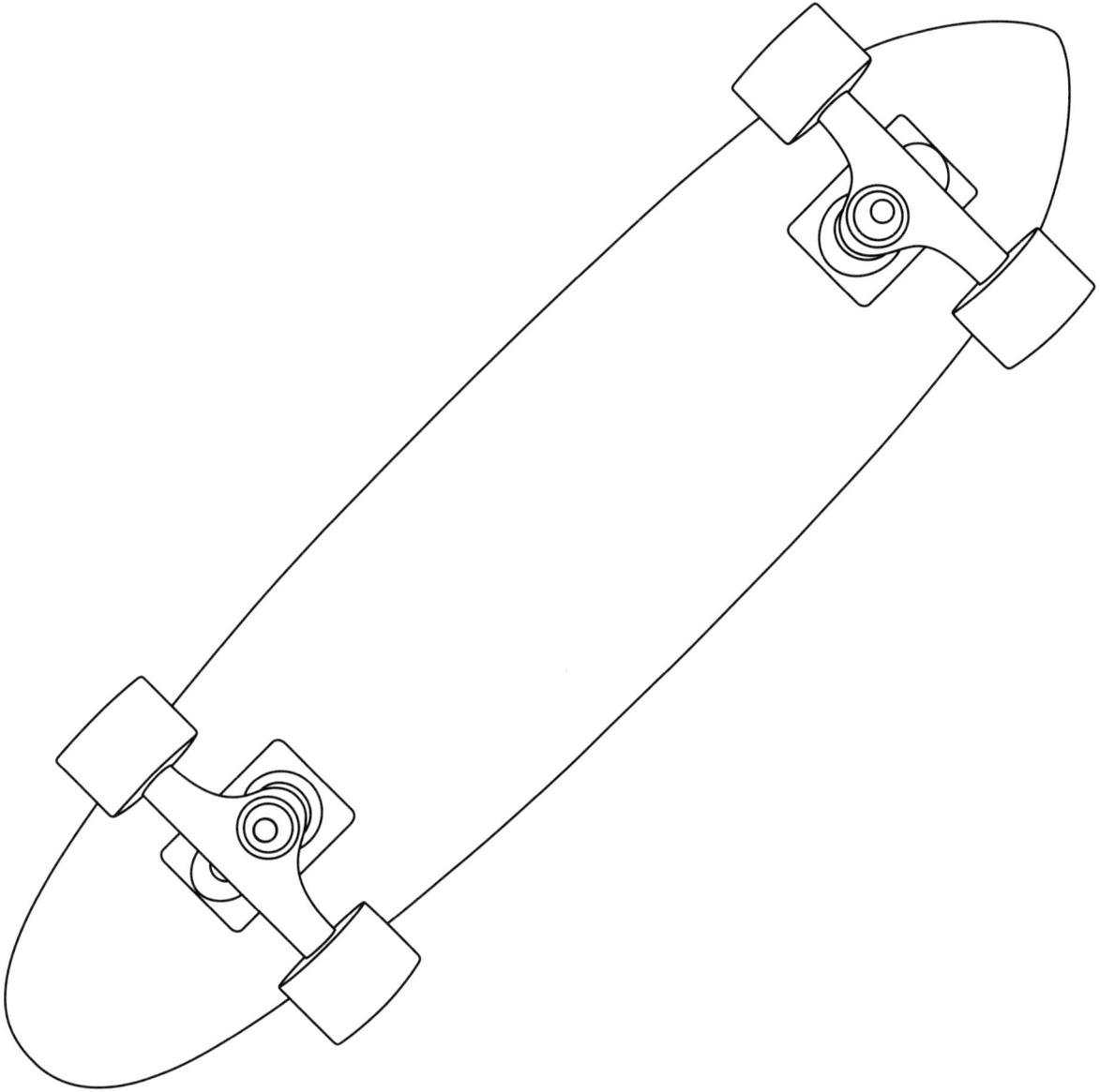

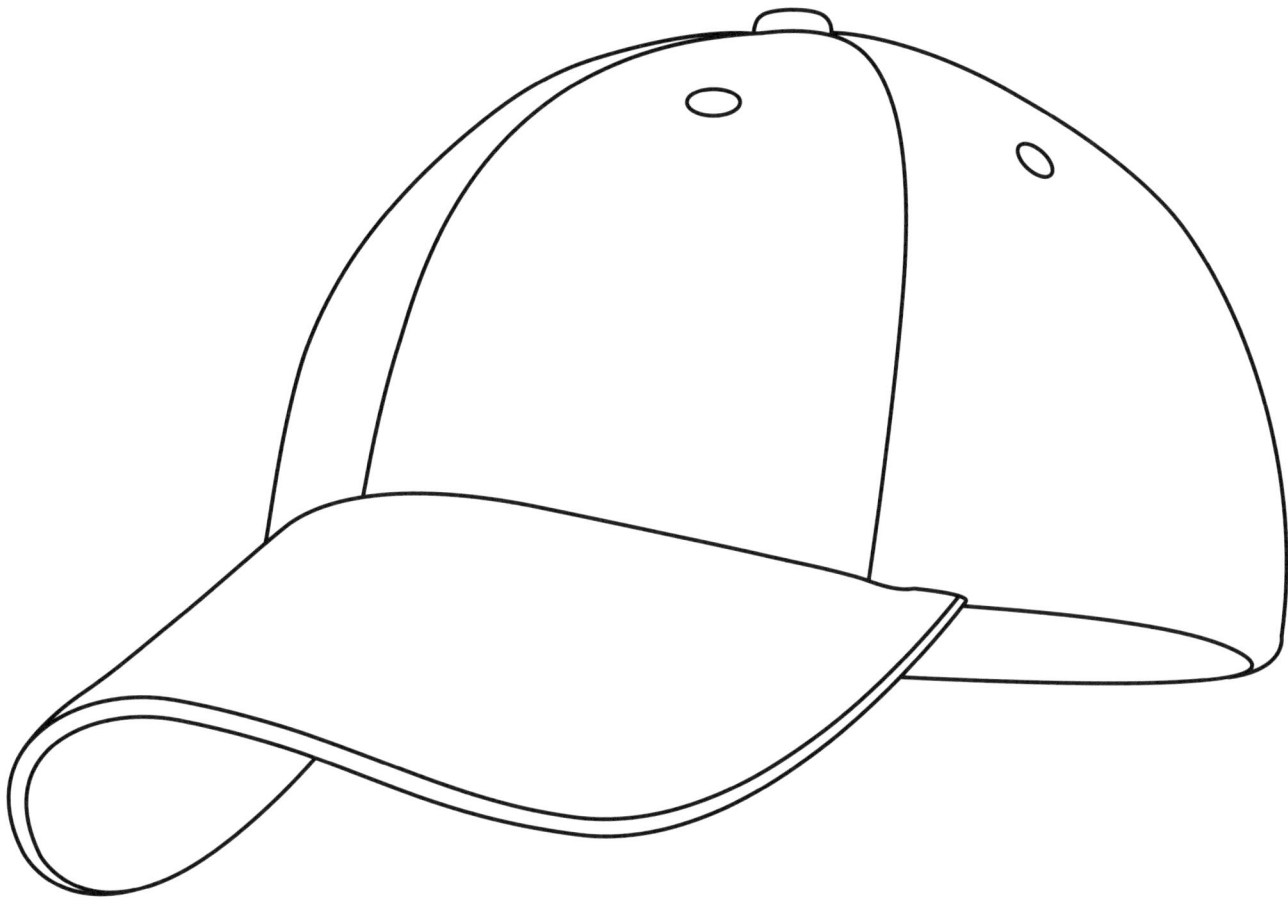

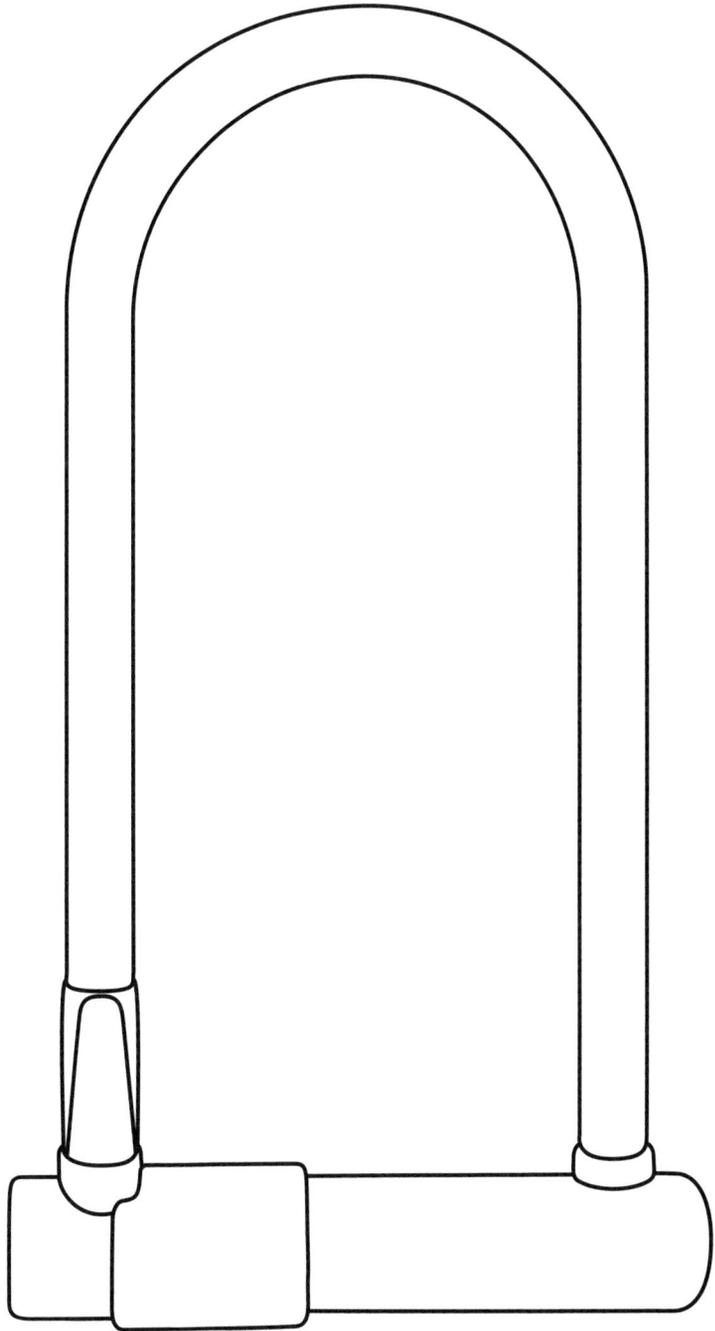

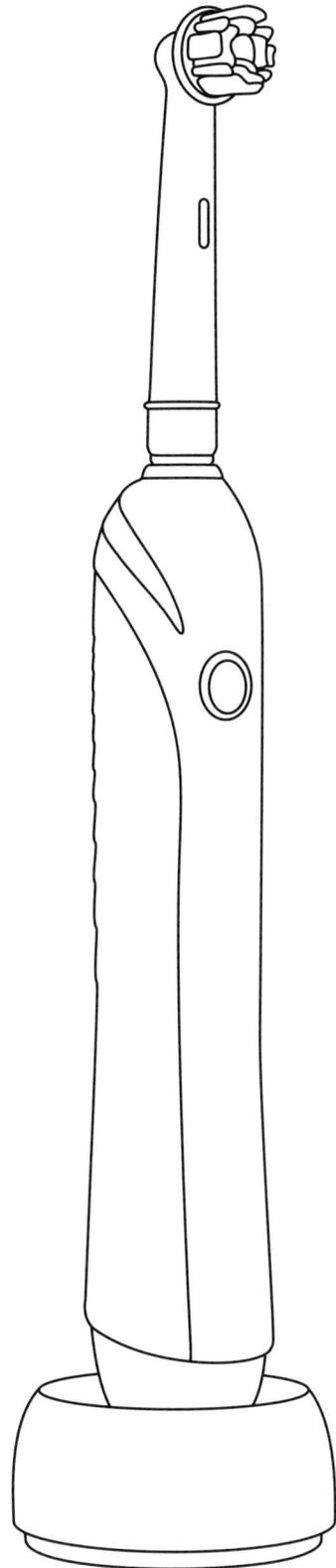

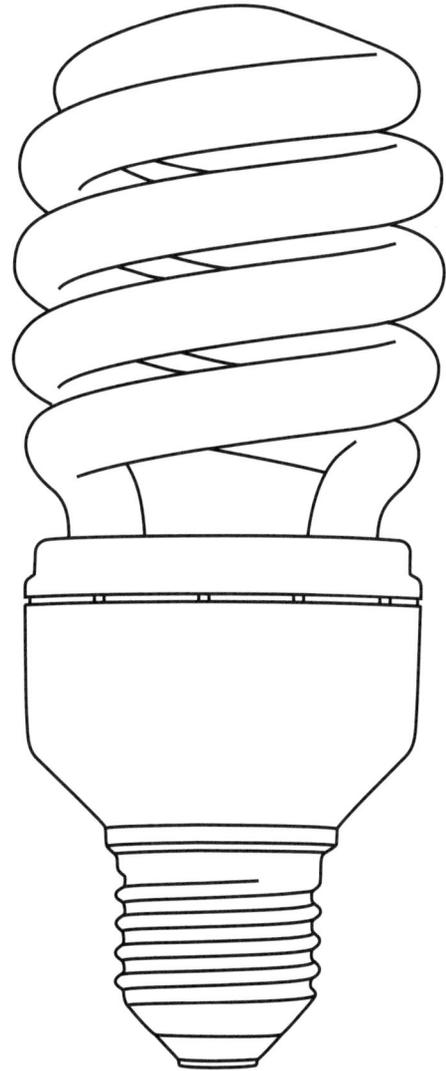

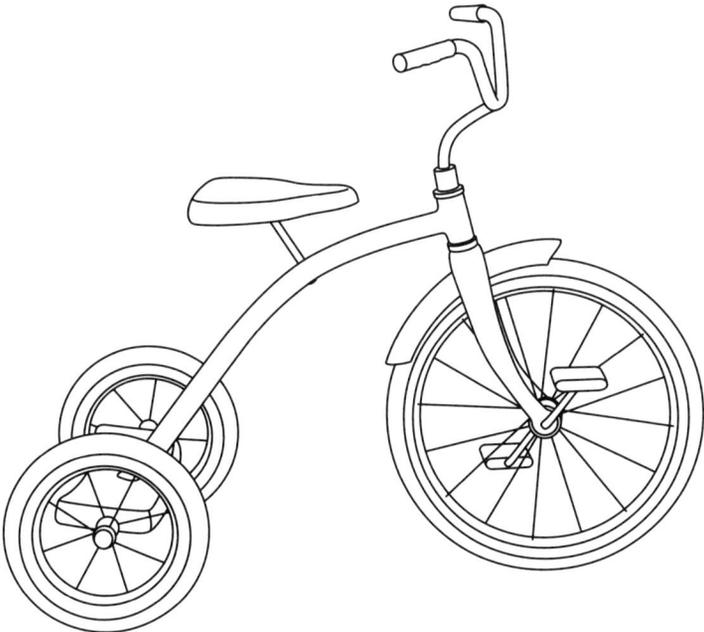

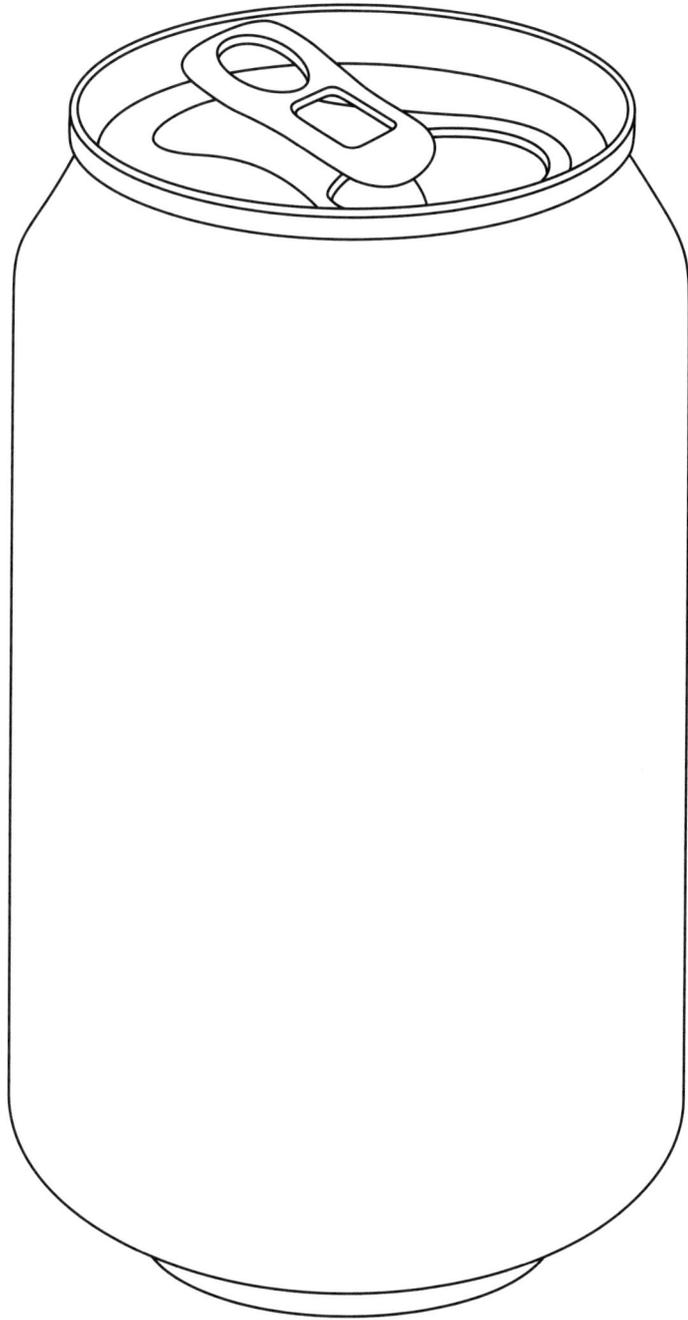

Michael Craig-Martin
*COLOURING*

All images © 2015 Michael Craig-Martin

Design: Michael Craig-Martin
Print: printed in Germany by
Lösch MedienManufaktur GmbH & Co. KG

First published by Koenig Books, London, 2015

ISBN 978-3-86335-873-0
(Koenig Books, London)

Koenig Books Ltd
At the Serpentine Gallery
Kensington Gardens
London W2 3XA
www.koenigbooks.co.uk

Distribution:

Germany & Europe
Buchhandlung Walther König
Ehrenstr. 4, 50672, Köln
Tel. +49 (0) 221 / 20 59 6-53
Fax +49 (0) 221 / 20 59 6-60
verlag@buchhandlung-walther-koenig.de

UK & Ireland
Cornerhouse Publications
HOME
2 Tony Wilson Place, UK-Manchester, M15 4FN
Tel. +44 (0) 161 212 3466
Fax +44 (0) 161 236 9079
publications@cornerhouse.org

Outside Europe
D.A.P. / Distributed Art Publishers, Inc.
155 6th Avenue, 2nd Floor, New York, NY 10013
Tel. +1 (0) 212 627 1999
Fax +1 (0) 212 627 9484
eleshowitz@dapinc.com